Bonnie Yochelson

D0391083

PHAIDON
not a mint copy

JACOB
RIIS
55

NOV 14 2014

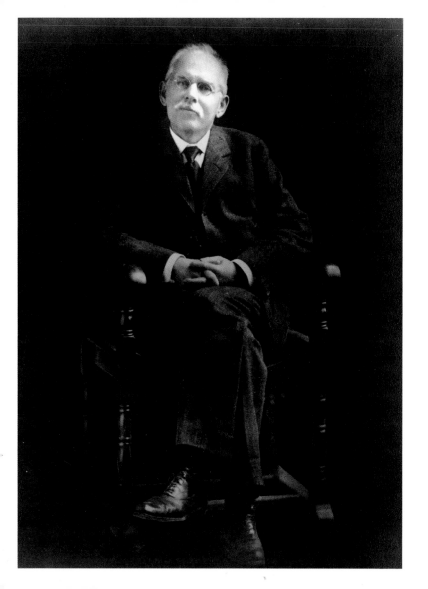

In his autobiography *The Making of an American*, Jacob Riis bluntly wrote, 'I am downright sorry to confess here that I am no good at all as a photographer, for I would like to be.' In the same breath, however, he declared a firm resistance to mastering darkroom technique: 'I do not want it explained to me in terms of $HO_2$ [sic] or such like formulas, learned, but hopelessly unsatisfying.' He explained that he took up photography 'not exactly as a pastime. It was never that with me. I had use for it, and beyond that I never went.'

Riis was a professional journalist, an inspired storyteller, and an impassioned reformer. Beginning as a police reporter for the *New York Tribune* in 1877, he wrote hundreds of newspaper columns, dozens of magazine articles, fifteen books, and delivered slide lectures across the United States. After his death in 1914 his family gave his personal papers, which he had annotated for future readers, to the Library of Congress. Riis did not bother to save his collection of photographs, however, since it carried no meaning for him apart from on the printed page and in the lecture hall. Miraculously, his negatives, lantern slides and publishers' work prints were found thirty-four years later in the attic of the house on Long Island where his family had once lived. It is therefore especially ironic that Riis is now considered a revolutionary photographic artist.

There are two explanations for Riis's modern reputation. The first is the sheer power of the images. His photographs of New York's immigrant poor – faces emerging from the filthy tenements, cheap lodging houses, stale beer dives, fetid docksides, and the crowded street corners of Mulberry Bend, Poverty Gap and Hell's Kitchen – are unique and shocking. There is simply no other photographic record of the immigrants who left Italy and eastern Europe in the 1880s and 1890s and made their homes in the crowded New York City slums.

For today's avid photography audience, it is difficult to believe that someone without artistic ambition could make photographs that are so compelling.

The second explanation involves Alexander Alland, Sr., the photographer who in 1946, with the help of Riis's son Roger William, retrieved the box of photographs from the Long Island attic. Alland did more than find the box. He made fifty beautiful exhibition prints from Riis's negatives for the 1947 landmark exhibition 'Battle with the Slum' at the Museum of the City of New York. He also wrote a book entitled *Jacob A. Riis, Photographer and Citizen*, illustrated with eighty-two of these prints and published in 1973. Although Alland was careful to explain Riis's casual practice of photography, his own superb craftsmanship and passionate advocacy of Riis as 'America's first true journalist-photographer' helped convince modern viewers to accept Riis as a committed social photographer comparable to Progressive-era figures like Lewis Hine, New Deal documentarians like Dorothea Lange, and magazine photojournalists like W. Eugene Smith. Modern critics have even compared Riis's haphazard technique to the aesthetic experiments of 1960s street photographers like Garry Winogrand. Perhaps Alland went too far with these claims. Riis took great photographs but was not a great photographer. He brilliantly exploited the power of photographs as evidence, but unlike Hine, Lange and Smith, he did not compose pictures with the camera, nor did he attempt to master the craft of photography.

Jacob Augustus Riis was born in 1849, the third of fourteen children, in the medieval town of Ribe, Denmark. A restless child and mediocre student, Riis disappointed his schoolteacher father by forsaking a 'literary career' to become a carpenter. At sixteen, he left Ribe for Copenhagen to apprentice with

a master-builder, and five years later, in 1870, went to America. Seeking adventure, Riis also wished to improve his income and social position so as to win the hand of Elisabeth, his childhood sweetheart, who had rejected him the previous year. Although his trade, his northern European Protestant heritage, and his rudimentary knowledge of English gave him an advantage over many new immigrants, Riis failed to find steady work or to save money during his early years in America. Wandering from New York City through upstate New York, Ohio and Pennsylvania, he worked on an assortment of jobs as a carpenter and travelling salesman. His luck began to improve when in 1873 he returned to New York City and was hired as a newspaper reporter, earning ten dollars a week. By the end of 1875 he had saved enough money to propose marriage again, and although she had been engaged in the interim, Elisabeth accepted. After Riis's victorious return to Denmark for the wedding, the couple set up house in the summer of 1876 in Brooklyn, and the following year, the first of their six children was born.

On a whim, Riis purchased a magic lantern, or stereopticon, and briefly gave up newspaper work for advertising. He assembled glass slides announcing local businesses, and projected them onto a 10 x 10 foot white sheet strung between trees. To attract an audience, he alternated advertisements with hand-coloured views of tourist sites. In the 1870s magic lantern shows were popular and varied in purpose from genteel travel lectures to outdoor announcements of election results. After a year, Riis's advertising career ended when he stumbled upon a labour strike in Elmira, New York, and was run out of town.

In the autumn of 1877 Riis was hired by the *New York Tribune* and was soon promoted to police reporter, with a comfortable salary of twenty-five dollars a

week. The police reporter, Riis explained, 'is the one who gathers and handles all the news that means trouble to someone: the murders, fires, suicides, robberies, and all that sort, before it gets into court'. The reporters' office at 301 Mulberry Street, across the street from police headquarters, was in the middle of a slum, and Riis, working at night, became intimate with the worst doings of New York's poor. The fierce competition among reporters and the reluctance of the police to divulge information demanded formidable energy and sharp wits. Leaving work between two and four in the morning, Riis routinely walked down the Bowery to the Brooklyn-bound Fulton Street Ferry, 'poking about among the foul alleys and fouler tenements ... sounding the misery and the depravity of it to their depth'.

Riis's search for answers to the housing problem of the poor began in earnest when the *Tribune* transferred him from night to day work. He explained: 'A new life began. I had been absorbing impressions up till then. I met men now in whose companionship they began to crystallize, to form into definite convictions; men of learning, of sympathy, and of power. My eggs hatched.' Riis was not an original thinker, but he was a conscientious student. His primary mentor was Felix Adler, head of the 1884 Tenement House Commission, and his day-to-day adviser was Roger S. Tracy, a statistician for the health department. Like Adler, Riis believed that 'it is not the squalid people that make the squalid houses, but the squalid houses that make the squalid people.' As his beliefs formed, however, Riis's frustration grew: 'I wrote, but it seemed to make no impression.' He was to find an answer in photography. In October 1887 he saw a notice in a newspaper on the German invention of a magnesium flash powder, which could illuminate a scene as a photographic negative was exposed, providing enough light to capture an image in the dark. Initially Riis had no intention of

taking photographs himself. As he later wrote, he 'began taking pictures by proxy', seeking the aid of John T. Nagle of the health department, who contacted Henry G. Piffard and Richard Hoe Lawrence, distinguished amateurs whose 'interest centered in the camera and the flashlight'. Their 'raiding party' made several outings, sometimes accompanied by policemen, 'half a dozen strange men invading a house in the midnight hour', setting off a flash fired from cartridges in a revolver. 'Soon', however, 'the slum and the awkward hours palled upon the amateurs.' Riis explained: 'I found myself alone just when I needed help most. I had made out the flashlight possibilities my companions little dreamed of.' Unwilling to take up the camera himself, Riis hired a professional but soon fired the man for 'trying to sell my photographs behind my back'. Having reclaimed them through the courts, in January 1888 Riis decided to purchase a camera. On his first foray to Potter's Field on Hart Island, he managed to expose only one of the twelve negatives he had brought with him.

Riis first showed photographs at a lantern-slide lecture held on 25 January 1888 at the Society of Amateur Photographers of New York, where Piffard and Lawrence were active members. The lecture filled the regular slot for the Society's monthly slide presentation at which members displayed their work. It was intended to showcase the Piffard and Lawrence flashlight photographs, but Riis, drawing on his prior experience with the magic lantern, gave the members more than the usual fare. Showing a hundred slides and speaking for two hours, he presented 'The Other Half, How It Lives and Dies in New York', a talk that garnered substantial press coverage and marked the turning point in his life. Borrowing the conventions of the 'sunshine and shadow' publications, which offered titillating tours of the city's seamy side, Riis led his audience through New York's tenements, 'the Frankenstein of our city civilization'. He highlighted

the ethnic diversity of poor neighbourhoods, noting that 'the one thing you shall vainly ask for in the chief city of America is a distinctive American community'. He indulged in crude ethnic stereotypes – the dirty Italian, the greedy Jew, the secretive Chinese – that were commonplace in his day, but he also offered vivid descriptions and sympathetic anecdotes about people he knew at first hand.

Throughout 1888 and 1889, Riis delivered his slide lecture in churches and theatres throughout the New York area, building a reputation as an expert on life in the city's slums; indeed, one reviewer referred to him as 'Doctor' Riis. He was shunned, however, by some religious groups, including his own Brooklyn congregation, where he was a deacon, because of the disreputable nature of his topic. As a result, Riis learned to adapt his presentation to his audience. In the 1889 Christmas issue of *Scribner's Magazine*, where his lecture first appeared in print, he made a subtle change to his title, which became 'How the Other Half Lives: Studies among the Tenements'. The new title was less sensational, less local, and more picturesque. In an 1891 version of the lecture delivered to an evangelical conference in Washington, DC, he enveloped his grisly tour in a sermon, and ended it not with a slide of the common trench at Potter's Field but with a depiction of Christ (now lost).

For the book-length version of *How the Other Half Lives*, published by *Scribner's* in November 1890, Riis offered his solution to the housing problem – 'philanthropy plus five percent'. If landlords offered decent housing and took a modest profit, the poor could sustain family life, improve their condition and enter the American mainstream. He expanded both the guided tour and the sermon, bolstering his argument with sanitation department statistics. Mustering every rhetorical tool, he invoked the spectre of political unrest and

the spread of disease to alarm those untouched by pangs of conscience. The book concluded with a verse from 'The Parable' by James Russell Lowell: 'Think ye that building shall endure/Which shelters the noble and crushes the poor?'

When Riis enlisted the aid of Lawrence and Piffard to take photographs for him, he had mapped out an ambitious itinerary. The newspaper reports of his lecture reproduced or mentioned about a third of the hundred images he showed. Among them were the notorious tenement Gotham Court on Cherry Street, the filthy alleys off Mulberry Bend (one of which was known as 'Bandit's Roost'; pages 18–19), a Chinese opium den on Pell Street, a black-and-tan dive on Broome Street, the docks near Hell's Kitchen on the West Side and at Corlears Hook on the East, an Arab lodging house on Washington Street, a police station lodging house, the Five Points House of Industry (a boy's home run by the Children's Aid Society), the Catholic Protectory, the police headquarters, the City Morgue, the Tombs, Bellevue Hospital, the Penitentiary on Blackwell's Island, and the Lunatic Asylum on Ward's Island. Many of these images became standards that Riis was to use over and over again.

In the three years between the January 1888 lecture and the publication of his first book, Riis supplemented his stock of photographs with those he took himself. The 1889 *Scribner's* article included eighteen photographs, eleven of which were new, and the 1890 book added nine more. For this, Riis began to acquire as well as produce images. He used model tenement plans from the Tenement House Commission, drawings from the annual report of the New York Association for Improving the Condition of the Poor (AICP), and photographs – one from the police department's 'rogue's gallery' and one perhaps from the files of the AICP of two ragged boys 'who didn't live nowhere'.

Riis's photographs, projected larger than life on a screen in the dark, provided radical new evidence of slum conditions. The same pictures in printed form were considerably less radical, since on the page, neither the imagery nor its method of reproduction was entirely new. Since mid-century, illustrated newspapers like *Harper's Weekly* and *Frank Leslie's* regularly published articles on New York's tenement poor, sending artists to draw scenes directly from life, which were then copied by engravers. During the 1880s, as increased immigration intensified overcrowding, these articles became more prominent and numerous. They appeared most often in the summer months, when the heat created greater health risks, and at Christmas, when charity was encouraged. Riis photographed the same types of subjects – tramps, opium dens, 'little mothers' caring for younger siblings – and some of the same locations, such as the Mott Street Barracks and Bottle Alley. His imagery, like his prose, combined stock images with first-hand experience. A posed photograph such as *Street Arabs in Sleeping Quarters* (page 47) conformed to an established street urchin typology, but *Five Cents a Spot* (page 45), taken in the dark, presented a shocking vision of the chaos and filth of cheap lodging houses.

When Riis's images were reproduced in daily newspapers, their photographic appearance was all but lost; they were transcribed as crude, single-line drawings. In the 1889 article, *Scribner's* accomplished illustrators recorded more detail but took considerable pains to compensate for the photographs' compositional or narrative incongruities. The engravers' bold decorative hatchings enhanced the artistic character of the images, but lessened their semblance to photographs. *Scribner's* further blurred the distinction between photograph and engraving by adding hand-drawn illustrations of similar subjects.

n the 1890 book, *Scribner's* reused the engravings made for the article but
nose to reproduce the additional photographs using the halftone process,
hich was still in its infancy. Halftone printing permitted the direct transfer of a
notograph to a metal plate, which was then inked and printed with text simul-
neously on the same page. By eliminating the need for an artist to copy the
notograph and by printing image and text together, the halftone eventually
evolutionized the printing industry. In introducing the halftone in Riis's book,
*cribner's* was probably drawn to the cost-effectiveness of the new process,
nd might have wished to capture, rather than mask, the unique, disconcerting
raphic qualities of the photographs. Reviews of the book applauded the illus-
ations but made no mention of the halftones.

*ow the Other Half Lives* became a bestseller, and Riis immediately began a
equel. In May 1892 'Children of the Poor' appeared in *Scribner's Magazine*,
nd that autumn, a book by the same name was published. Although modelled on
s predecessor, *Children of the Poor* was a prototype for Riis's later writings
nd lectures: not only did he sound an alarm about the cruelty and degradation
f poverty, he offered remedies – rescue societies, night schools, kindergartens
nd playgrounds – and reported on their progress. *Children of the Poor* proved
ss successful than *How the Other Half Lives*, perhaps because it was a sequel
r perhaps because it was more laboured. The earlier book had 'burst out
t last with a rush', while the sequel was the product of an intense year
f research.

n his first book, most of Riis's photographs illustrated a preconceived idea –
ne newsboy or the sweatshop – and were only loosely connected to the text.
or the second, photographs played an integral role in his research: he took

them as he collected anecdotes and gathered impressions. As a result, many of
the twenty-four new photographs in the book depict people whom Riis inter-
viewed, sometimes with comments about the photographic process. Describing
'Little Susie' of Gotham Court (page 67), for example, Riis related how she
pasted linen on tin covers 'with hands so deft and swift that even the flash could
not catch her moving arm, but lost it altogether'.

Riis's two books were meant to form a set, and the design and illustrations of
the sequel conform to the formula established in the first book. This time
*Scribner's* used a bewildering array of reproductive strategies: engravings and
halftones from drawings after Riis's photographs, halftones made directly from
his photographs, and engravings and halftones made from artists' drawings. To
correct the fuzzy appearance of the halftones in the first book, the photographs
in the second were heavily reworked with pen and ink. Although Riis was unlikely
to have been involved in the technical printing decisions, which were beyond
his expertise, he was concerned with the clarity of the reproductions. Several
of his prints from *Children of the Poor* are annotated with his instructions.
On the back of *Pietro Learning to Make an Englis' Letter* (page 71) he wrote
'Take out shadows back of faces', and on *Little Susie*, 'Fix can and hand of child,
ink out white spot bottom of picture.' As a result of these manipulations, all the
illustrations in the book, regardless of their source and reproductive technique,
have a relatively uniform – and to the modern eye, contrived – appearance.

While he was preparing *Children of the Poor*, Riis continued to use photographs
to illustrate his newspaper articles. Based on his 1891 survey of New York's
dumps, he wrote, 'Real Wharf Rats, Human Rodents that Live on Garbage Under
the Wharves'. When typhus broke out that winter, he made the rounds of the

police station lodging houses, photographing the city's homeless huddled in basements, publishing a series of articles, and presenting a slide lecture at the Academy of Medicine.

After the publication of his second book, Riis rarely used his camera, and when he did, the photographs were intended to illustrate a particular article. His diminishing interest in taking photographs was already apparent in May 1895, when he enlisted a staff photographer from the *Evening Sun*, where he worked from 1890 to 1901, to take pictures for his article on the clearing of Mulberry Bend.

Between 1895 and 1897, Riis may simply have been too busy for photography. He played a small but influential part in the administration of anti-Tammany mayor, William L. Strong, as an adviser to Police Commissioner Teddy Roosevelt, a member of the Small Parks Committee, and an officer of the Good Government clubs. With Roosevelt's help, Riis accomplished his two paramount political objectives: the closing of the police lodging houses and the construction of a small park on the site of Mulberry Bend. When Tammany reclaimed City Hall in 1898, Riis returned full-time to writing and lecturing, and his work began to take a retrospective turn. In 1900 he published *A Ten Years' War*, a summary of social reform progress since the publication of his first book. In 1901, suffering the effects of heart disease, he gave up his newspaper staff position and published *The Making of an American*, which became a national bestseller. The following year he presented *The Battle with the Slum*, an expanded version of *A Ten Years' War*. His celebrity increased after Teddy Roosevelt became president, but Riis was never financially secure and, despite his ill health, continued to write, travel and lecture until his death at the age of sixty-five. His

later books included two collections of tenement stories, a campaign biography of Roosevelt, and two nostalgic books about Denmark.

None of Riis's fictional volumes were illustrated with photographs, but all his non-fiction works were. Most of the photographs in the later works were not by Riis, for, with the exception of two photographs published in an 1898 article, he seems never to have picked up the camera after 1895. Riis had no shortage of photographs to illustrate urban poverty, but to demonstrate recent reforms – street paving, model apartments, small parks, public schools with playgrounds, vacation programmes and settlement houses – he scoured the files of municipal agencies and private charities. He collected prints, had copy negatives made and from them had lantern slides and copy prints prepared. Of the 415 negatives found in the attic box, roughly half are copy negatives of photographs by others. The most interesting photographs he acquired were a dozen Lewis Hine prints, purchased for three dollars each, for a 1911 *Century Magazine* article.

What happened in a few short years to turn Jacob Riis from a producer of photographs into a consumer? The answer, it seems, is that his idea caught on. Reformers learned that photographs were effective tools of persuasion, and professional photographers were pleased to oblige. The watershed event was the blockbuster 1900 'Tenement House Exhibition' organized by Lawrence Veiller, which in two weeks was viewed by ten thousand New Yorkers. Riis gave several of his photographs to the exhibition, including *Five Cents a Spot*, all of which were incorporated into a twenty-panel installation on tenement house conditions. The momentum created by the exhibition led to the establishment in 1902 of a Tenement House Department, which in its first year hired a staff photographer. The department had the authority to evacuate the worst tene-

ments, and its photographs were used to fend off absentee landlord lawsuits. In the department's first annual report, Commissioner Robert W. DeForest quipped, 'One good photograph in this class of work is worth several lawyers.'

Both Riis and the new department understood the power of photographs as evidence, and Riis acquired some department photographs for his lectures. Commissioner DeForest's dry wit and political savvy, however, signal the cultural divide between Christian moralists like Riis and a younger generation of Progressive reformers. Quite suddenly Riis had lost his position as an innovator in two worlds — social reform and photography. In 1887 Riis had taken the revolutionary step of using photographs to change public opinion. He took pictures for only five of his thirty-five-year career as a writer, and depended on others for their production. This haphazard engagement with the medium makes it very difficult to measure his influence on other photographers. By the time of his death, however, social-work photography was a viable profession.

What is certain is the tremendous power that Riis's photographs still exert today. They provide an invaluable record of a critical moment in American history and carry a huge emotional charge, not only because they are among the very few photographs we have of the poor and the powerless just before the turn of the century, but because they are so technically crude and raw. The blurred motion, the harsh flash, the imbalanced compositions, the overcrowded spaces, and the odd vantage points all contribute to our sense of immediate, direct encounter with the subjects. Riis's photographs are neither bits of unmediated reality nor aesthetic constructions. They are the unintended legacy of a man who called himself a photographer 'after a fashion'.

**Mullin's Alley, New York, 1887.** The tenements of the Fourth Ward on the Lower East Side created long narrow alleys like Mullin's, which became dumping grounds for trash and escape routes for law-breakers. Seven feet wide at one end and two feet wide at the other, Mullin's Alley served the latter purpose especially well. Riis used this photograph, taken by Richard Hoe Lawrence o Henry G. Piffard, in lectures and articles but not in his books. Located next t 32 Cherry Street, Mullin's Alley was down the block from the infamous Gothan Court, an early 'model' tenement built in the 1850s to replace the old ramshackle houses of the once-elegant Cherry Hill.

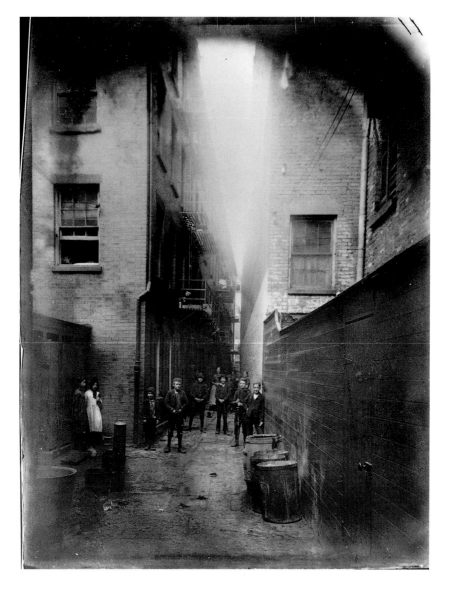

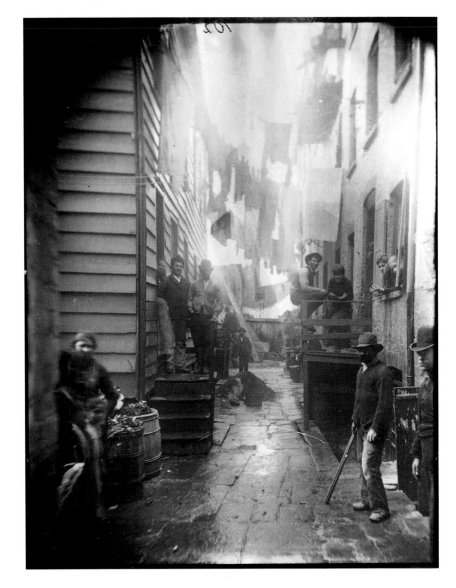

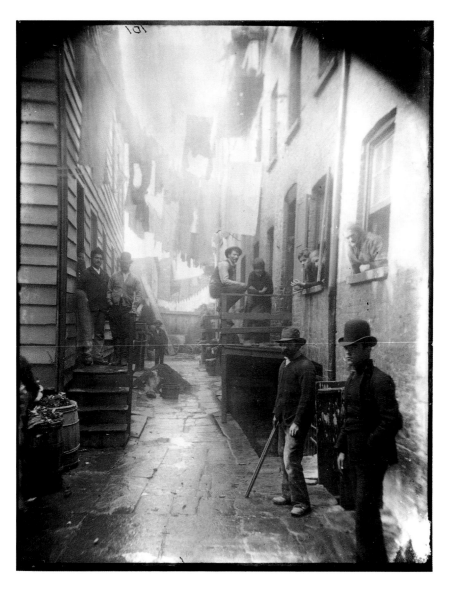

**(previous page) Bandit's Roost, New York, 1887.** Bandit's Roost was the nickname for an alley next to 59 Mulberry Street in the heart of Mulberry Bend – a notorious slum not far from Riis's office. The alley was fronted by cellar beer dives, which attracted a rough crowd. This photograph, like several of those taken by Lawrence or Piffard, was made with a stereoscopic camera, which had two lenses and produced a pair of images on one double-width negative. On the far left of the left-hand image is a group of women and children, and on the far right of the right-hand image is a particularly menacing tough. Riis used both versions in print and in lectures, and even had a lantern slide hand-coloured, which rendered the scene picturesque.

**An All-Night Two-Cent Restaurant in 'The Bend', New York, 1887.** In *How the Other Half Lives*, Riis described a stale beer dive, euphemistically called a 'two-cent restaurant': 'The beer is collected from the kegs put on the sidewalk by the saloon-keeper to await the brewer's cart, and is touched up with drugs to put a froth on it. The privilege to sit all night on a chair, or sleep on the table, or in a barrel, goes with each round of drinks. Generally an Italian, sometimes a Negro, occasionally a woman, "runs" the dive. Their customers, alike homeless and hopeless in their utter wretchedness, are the professional tramps, and these only.' Taken by Lawrence or Piffard, this photograph shows the beer dive just before the police raided it. Riis went along, in his words, 'as a kind of war correspondent'.

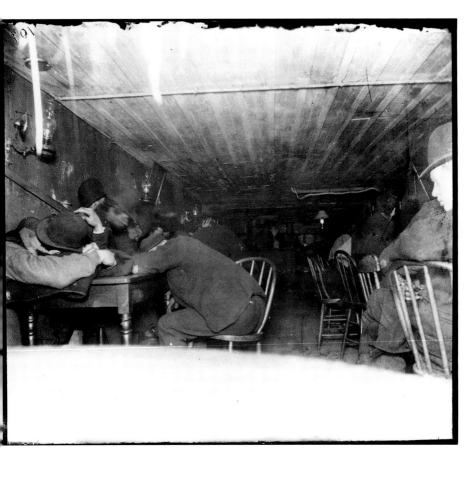

**A 'Downtown Morgue', New York, 1887.** Although Riis criticized New York's 'color line', which prevented African-Americans from working as skilled labourers and barred them from certain neighbourhoods, he was still intolerant of the races socializing together. With Lawrence and Piffard in tow, Riis visited two 'black-and-tan' saloons, which he called 'the border-land where the white and black races meet in common debauch'. This saloon was in a cellar on Thompson Street, and the other was on Wooster Street; the neighbourhood now called SoHo was in Riis's day known as 'Old Africa'.

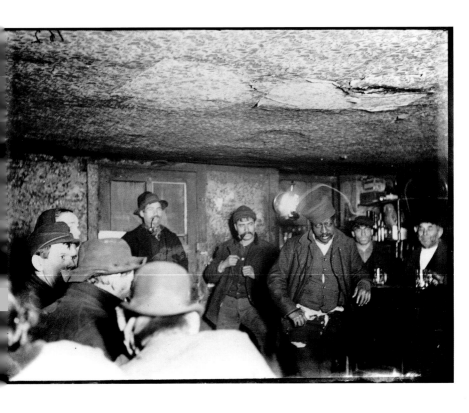

**Bunks in a Seven-Cent Lodging House, Pell Street, New York, 1887.** Happy Jack's Canvas Palace, which offered a lodger a strip of canvas strung between rough timbers without any covering, was the least expensive of the licensed lodging-houses. In *How the Other Half Lives*, Riis gave life to this static image, which was taken by Lawrence or Piffard: 'On cold winter nights, when every bunk had its tenant, I have stood in such a lodging-house ... and listening to the snoring of the sleepers like the regular strokes of an engine, and the slow creaking of the beams under their restless weight, imagined myself on ship board and experienced the very real nausea of sea-sickness.'

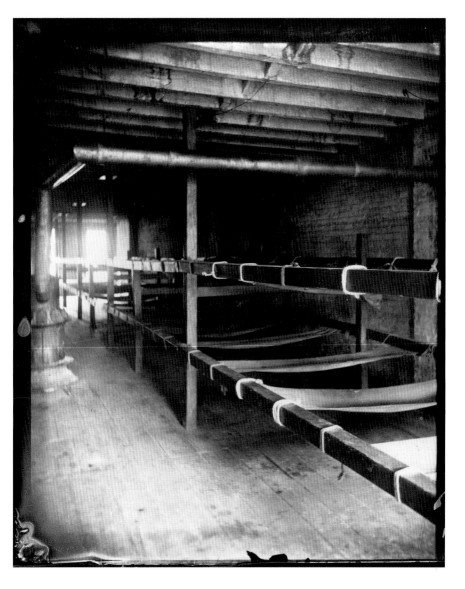

**The Tramp, New York, 1887.** Riis had no sympathy for tramps, whom he felt were encouraged to remain lazy by charity. His own rise from poverty strengthened his vehemence on the subject. In *How the Other Half Lives* Riis tells how this 'particularly ragged and disreputable' tramp accepted ten cents in exchange for having his photograph taken and then removed his pipe from his mouth and refused to put it back unless Riis raised the fee to a quarter. 'The man, scarce ten seconds employed at honest labor even at sitting down, at which he was an undoubted expert, had gone on strike.' The photograph was probably taken by Lawrence or Piffard; Riis later returned to the yard and photographed it himself (page 63).

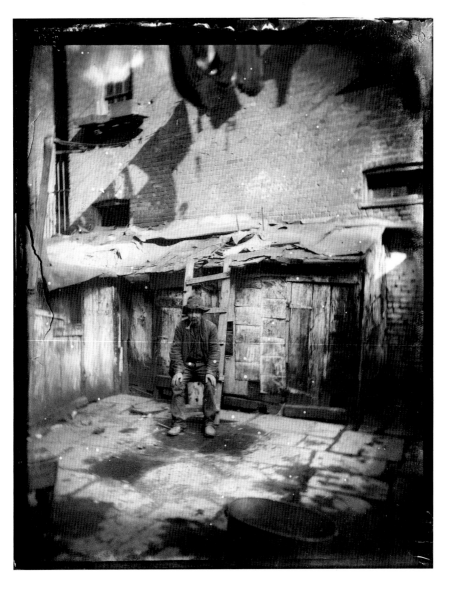

**A Growler Gang in Session, New York, 1887.** In *How the Other Half Lives*, Ri describe his encounter with the 'Montgomery Guards' on the West 37t Street dock: 'I came once upon a gang of such young rascals passing the growle [bucket of beer] after a successful raid of some sort, and having my camer along, offered to "take" them. They were not old and wary enough to be shy of th photographer, whose acquaintance they usually first make in handcuffs and th grip of a policeman.' To enliven the picture, the boys borrowed a sheep from nearby slaughterhouse.

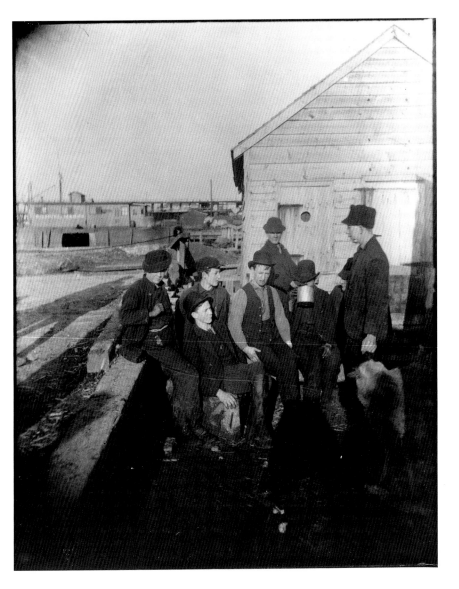

**'Showing Their Trick', Hell's Kitchen Boys, New York, 1887.** Members of the 'growler gang' posed for Riis 'in character', showing how they robbed drunks. According to Riis, two of the gang – Dennis 'the Bum' and 'Mud' Foley – were subsequently arrested for robbing a Jewish pedlar and trying to saw off his head 'just for fun'. The two photographs of the gang appeared in Riis's first slide lecture and were probably taken by Lawrence or Piffard.

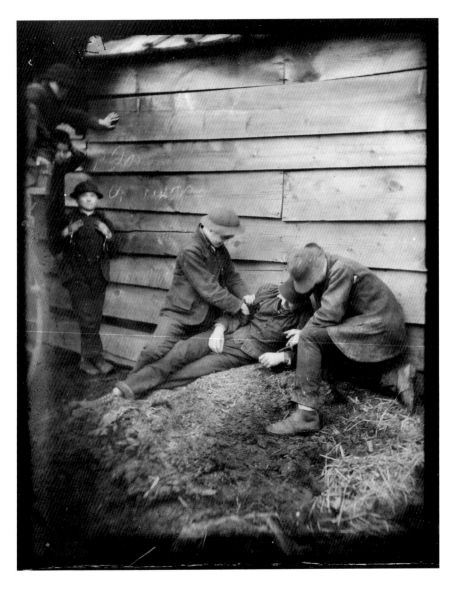

**Dockrats in Quarters, New York, 1887.** Working with Lawrence and Piffard, Riis captured this photograph of the 'Short Tail Gang' under the pier at Corlears Hook on the East River. The photograph was taken from a police boat, which was out 'hunting river thieves'. In his lectures, Riis explained that like rats, the gang would hide under the pier by day and 'come out and sneak along the water front by night in search of prey.

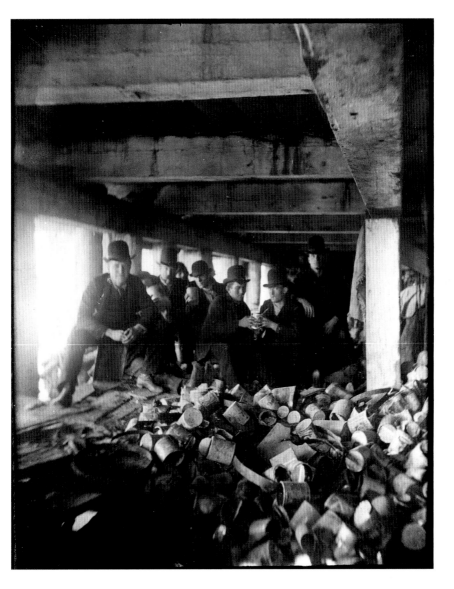

**Prayer-Time in the Nursery – Five Points House of Industry, New York, 1888**

The Five Points, only a block south of Mulberry Bend, was New York's most infamous antebellum slum. In the 1850s the Old Brewery, which had helped spawn the slum, was demolished for the Five Points Mission and House of Industry, which rescued abandoned and abused children. This photograph, taken by the photographer Riis hired before he learned to use the camera himself, was a staple of his slide lectures and appeared in *How the Other Half Lives*. The huge scratch in the negative dates from Riis's day.

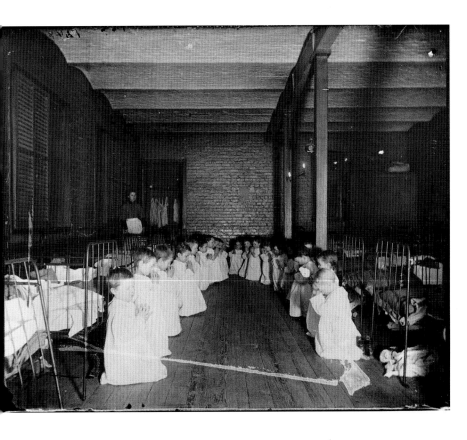

**James M'Bride, One of the City's Pensioners, New York, 1889.** This image of blind beggar illustrated a July 1889 news story about the city's Annual Pensio Day, when the Superintendent of Outdoor Poor distributed twenty thousan dollars to the city's blind population. Riis reported, 'There is joy in Blindman Alley to-day', but the amount each pensioner received was no more than fort dollars, which typically went directly to their landlord.

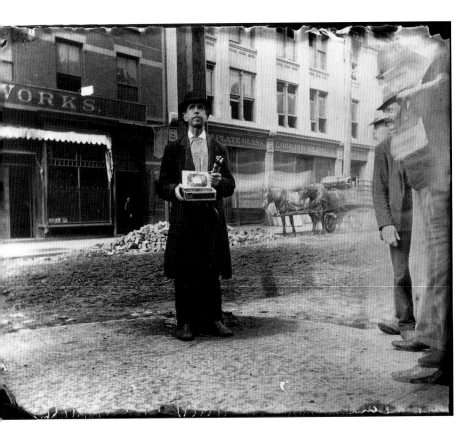

**Ash Barrel of Old, New York, 1889.** An ash barrel and bucket stand in front of a kosher restaurant, with the handles of a barrow visible on the right. The symbolic meaning of the barrel, not the photograph's rich detail, was what interested Riis. It was a visual reminder of the shortcomings of Tammany-controlled city government: tardy garbage collection in poor neighbourhoods posed a serious health risk. The barrel and bucket appear as a small drawing at the end of the first chapter of *How the Other Half Lives*.

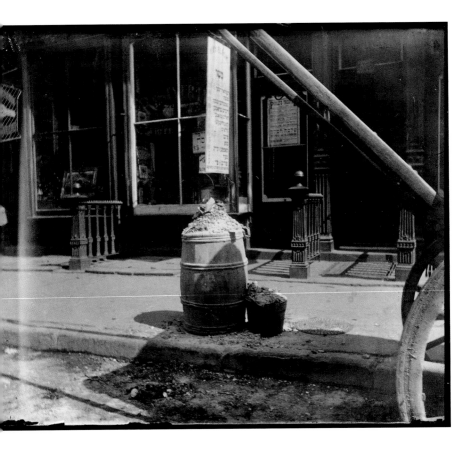

**In the Home of an Italian Ragpicker, Jersey Street, New York, 1889.** When Riis took this photograph of an Italian mother with her tightly swaddled baby in the windowless room, he could barely see what was before his camera. The flash powder, which he placed in a frying pan and lit with a match, illuminated the scene at the moment of exposure. It failed, however, to capture what Riis called the 'vivid and picturesque costumes' of the Italian women, which 'lend a tinge color to the otherwise dull monotony of the slums they inhabit'. Reproduced a an engraving in *How the Other Half Lives*, the image accompanied a description of Italian women as 'faithful wives and devoted mothers'.

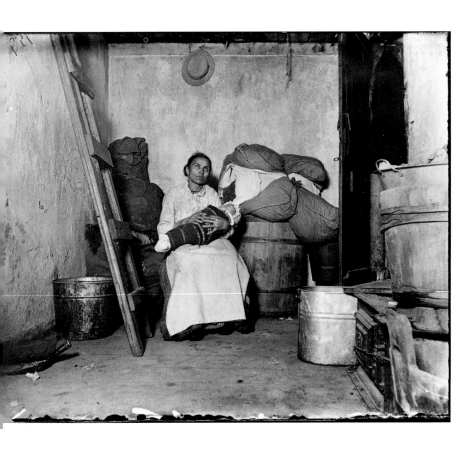

**A Flat in the Pauper Barracks, West 38th Street, With All Its Furniture New York, 1889.** This picture shows the decrepit, sparsely furnished room of an impoverished couple who lived in a large tenement in the Hudson River waterfront neighbourhood nicknamed 'Hell's Kitchen'. The couple hovered in the doorway when Riis took the photograph and moved at the moment of exposure causing their faces to appear blurred. In *How the Other Half Lives*, the couple were cropped out of the image.

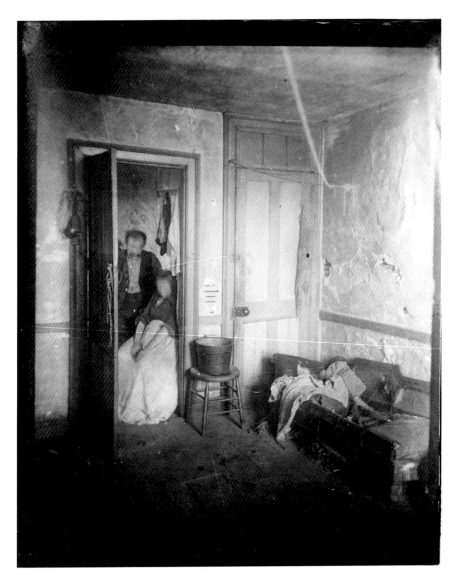

**Lodgers in a Crowded Bayard Street Tenement – 'Five Cents a Spot', New York, 1889.** The huge influx of Italian immigrants to Mulberry Bend left thousands homeless and forced to sleep in illegal lodging houses for 'five cents a spot'. This room and an adjoining one held fifteen men and women and a week-old baby. Riis took the photograph on a midnight expedition with the sanitary police, who reported overcrowding. In his autobiography, he explained, 'When the report was submitted to the Health Board the next day, it did not make much of an impression – these things rarely do, put in mere words – until my negatives, still dripping from the dark-room, came to reinforce them. From them there was no appeal.'

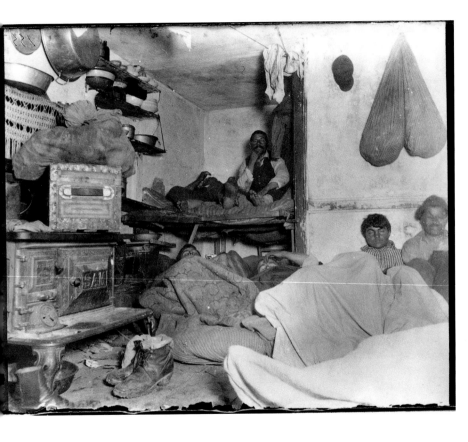

**Street Arabs in Sleeping Quarters, New York, 1889.** Riis devoted a chapter of *How the Other Half Lives* to 'street arabs', nomadic children who left the tenements to live by their wits on the streets. He admired the boys' self-reliance and 'rude sense of justice', and supported efforts to guide rather than tame them. This photograph, one of three showing the boys in various 'sleeping quarters' was posed in broad daylight, despite the claim in a *Scribner's* advertisement that it was 'from [a] flashlight photograph'.

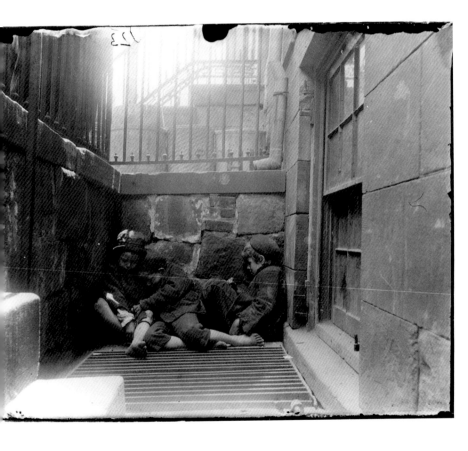

**Getting Ready for Supper in the Newsboys' Lodging-House, New York, 1890**

The Children's Aid Society, founded in 1853, operated six boarding houses for homeless children. The Duane Street lodging, a few blocks from Newspaper Row and City Hall, offered room and board to newsboys and bootblacks. To promote self-respect, the Society charged the boys six cents for a bed, six cents for breakfast, and six cents for supper. In *How the Other Half Lives*, Riis apologized for this photograph, noting that the boys had refused to pose for him and were 'quite turbulent'. The photograph reveals an interesting detail: two prayer shawls worn by religious Jews under their garments, one hanging on a nail and the other in the back pocket of the young man on the right.

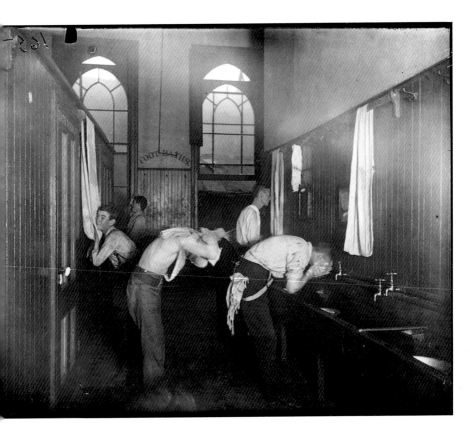

'Knee-Pants' at Forty-five Cents a Dozen – A Ludlow Street Sweater's Shop New York, 1890. Riis devoted a chapter of *How the Other Half Lives* to 'the sweaters of Jewtown', who served as middlemen in the clothing business centred in the Tenth Ward on the Lower East Side. The sweaters hired recent immigrants to work at sewing machines in tenements for as many as sixteen hours a day and as little as two dollars a week, all in violation of factory labour laws. Riis visited the sweatshop with a Yiddish-speaking guide. In this photograph the workers are 'learners' who had 'come over' only a few weeks earlier.

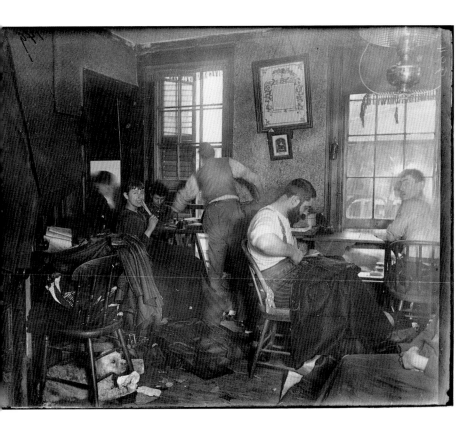

**A Child of Twelve at Work Pulling Threads, New York, 1890.** Riis wrote often about the illegal employment of children under fourteen years old. On a visit to Ludlow Street he photographed this boy, who had a sworn certificate showing that he was sixteen but admitted that he was only twelve. Captioned 'Christmas in a Sweat-shop', the image appeared in *The Golden Rule*, 19 December 1895, accompanying one of Riis's frequent Christmas stories about the poor.

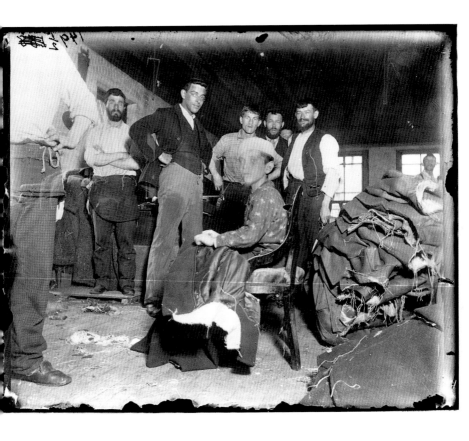

**Bohemian Cigarmakers in their Tenement, New York, 1890.** In *How the Other Half Lives*, Riis explained that more than half the Bohemian immigrants in New York worked as cigarmakers under conditions worse than those in the clothing sweatshops. Living and working in tenements owned by their employers, the Bohemians were 'in virtual serfdom'. This team of father, mother and child, who lived on East 10th Street with thirty-five other families, worked from dawn until nine in the evening, breathing toxic fumes, to produce four thousand cigars a week. The family was paid fifteen dollars a week, and their rent for three small rooms, two without windows, was nearly twelve dollars a week.

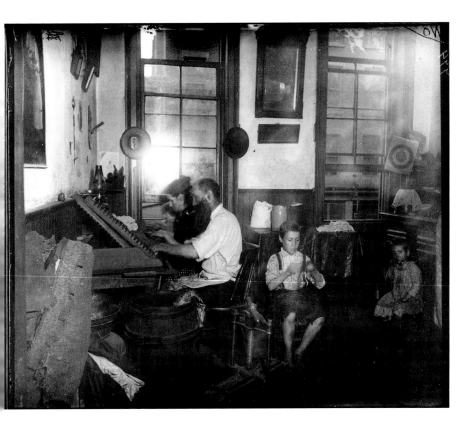

**The Mulberry Bend, New York, 1890s.** Named after a bend in Mulberry Street south of Bayard Street, this Italian neighbourhood of the Sixth Ward, seven blocks south of Riis's office, was one of the city's worst slums. Riis's crusade to tear it down and replace it with a park took nine years, from the city's purchase of properties in 1888 to the opening of Mulberry Bend Park in 1897. The picturesque photograph of dilapidated buildings and strolling shoppers fails to suggest the Bend's scandalously high crime and infant mortality rates.

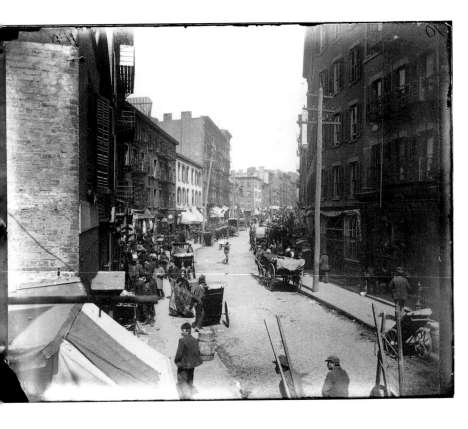

**Roof of the Mott Street Barracks, New York, 1890s.** The Mott Street Barrack was a vast tenement with five connected buildings facing Mott Street and fou others directly behind them, separated only by a 5-foot wide yard. This narrov yard, which contained foul-smelling outhouses for both the front and rear build ings, was the children's principal play area. As an alternative, mothers too their children to the roof for fresh air and light. Although the Barracks stoo across the street from the Board of Health, thirty-five babies died ther between 1888 and 1891. Riis photographed the façade of the Barracks, the roo and the narrow yard, but published only the last.

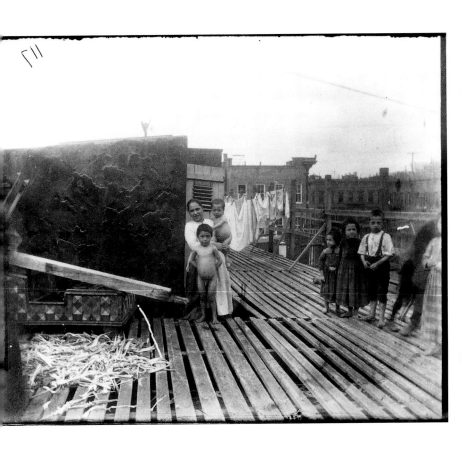

**Old House Torn Down in Bleecker Street, New York, 1890s.** This demolition si[te]
on Bleecker Street between Greene and Mercer Streets was a few bloc[ks]
from Riis's office. It affords a clear view of an old wood-frame rear teneme[nt]
abutting a new brick building. Riis never published this photograph.

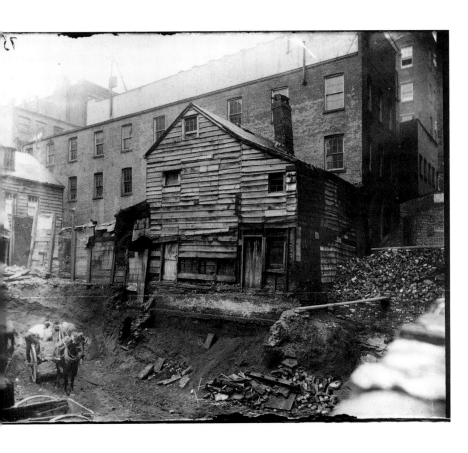

**Tramp Lodgings in a Jersey Street Yard, New York, 1890s.** For this picture Ri
returned to the same yard at Jersey and Mulberry Streets, only a block from h
office, in which *The Tramp* had been photographed in 1887 (see page 27
Tenants paid a dollar a month to live in these shacks made of old boards and ro
tin. By 1902, when the photograph appeared in *The Battle with the Slum*, th
yard had been demolished.

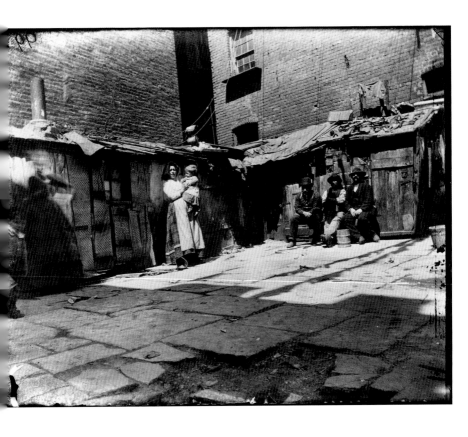

**The Trench in the Potter's Field, New York, 1891.** Potter's Field on Hart Islan in the Long Island Sound was the burial ground for the city's unidentifie and indigent. In *How the Other Half Lives*, Riis reported that one of ever ten New Yorkers was buried there. 'In the common trench ... they lie packe three stories deep, shoulder to shoulder, crowded in death as they were i life, to "save space".' Riis took his first photograph at Potter's Field, but thi image, which shows gravediggers burying the coffins of children, is part of later series.

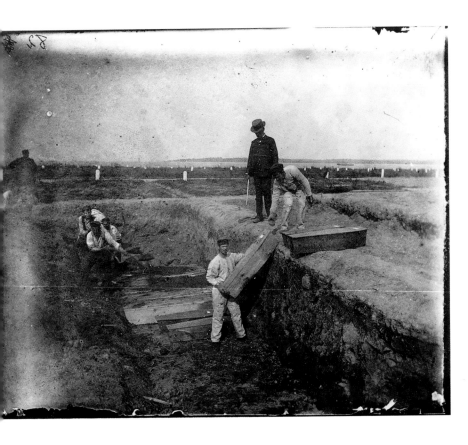

**Little Susie at her Work, New York, 1892.** In *Children of the Poor*, Riis describes the enterprising life of Susie, one of the 'little toilers' who lived in Gotham Court. Each day Susie pasted linen on two hundred tin covers for pocket-flasks and earned sixty cents. She ran errands for pennies before work and attended school in the evening.

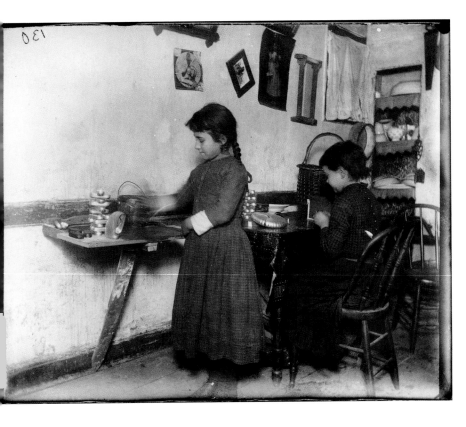

**Minding the Baby, New York, 1892.** Smaller children were often asked to 'mind the baby' while their mothers worked outside the home. This photograph shows a 'little mother' with baby in a Cherry Hill tenement yard. The household goods surrounding them suggest that someone, perhaps their family, was moving in or out of the tenement. The surrounding objects were cropped out when the image was published in *Children of the Poor*.

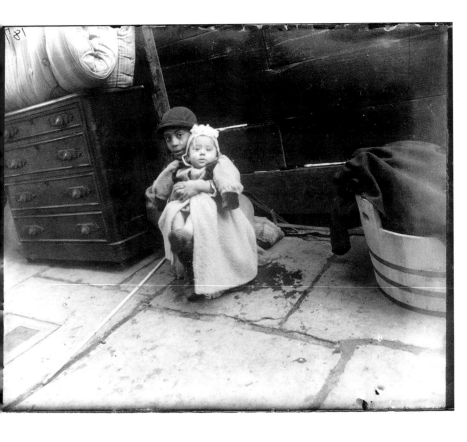

**Pietro Learning to Make an Englis' Letter, New York, 1892.** Pietro, who lived i Jersey Street, had been maimed in a streetcar accident. Unable to work as bootblack, he was learning to write English in the hope of finding a job that di not require physical labour. In *Children of the Poor*, Riis told Pietro's story i detail, asking sympathy for the child who no longer laughed.

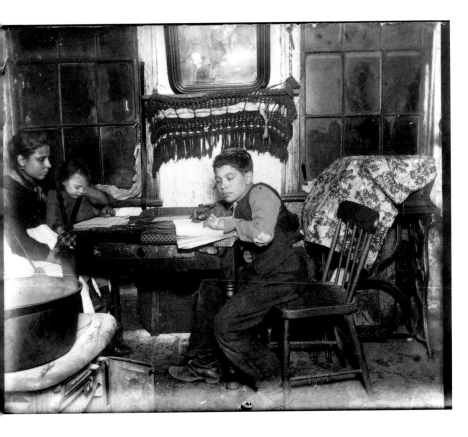

**'I Scrubs' – Katie who Keeps House in West Forty-ninth Street, New York**, **1892.** When Riis met nine-year-old Katie at the 52nd Street Industrial School he asked what kind of work she did, and she answered, 'I scrubs.' Katie and her three older siblings took their own flat after their mother died and their father remarried. The older children worked in a hammock factory, and Katie kept house. When asked if she would pose for this picture, which appeared in *Children of the Poor*, Katie 'got right up … without a question and without a smile'.

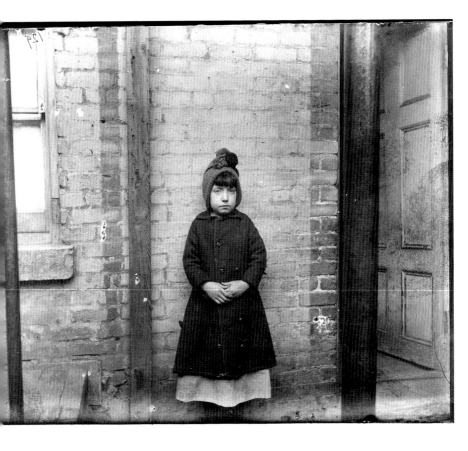

**Saluting the Flag, New York, 1892.** The Children's Aid Society operated twenty one industrial schools to serve children who could not attend public school either because they were too dirty and ragged, or because they worked during the day. The schools' eight thousand students were taught English and practical skills, and received a hot meal and medical attention. Shortly before Riis wrote *Children of the Poor*, the schools instituted a morning flag salute. Each day, 'the best scholar of the previous day' stood before the group with the flag, which he or she was then given for the day. The photograph shows the Mott Street Industrial School.

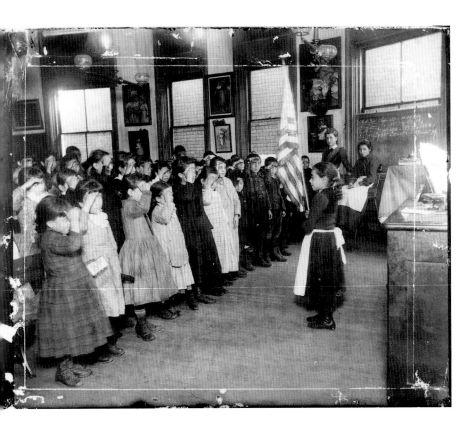

**First Board of Election in the Beach Street Industrial School, New York, 1892**

One Americanization ritual gave birth to a second: a plan to vote for or against the morning flag salute. The children were given ballots and told to discuss the issue with their parents. Each school selected a 'board of election' to supervise the vote and submit the results to the principal. At the Beach Street School where most of the children were Italian, the students selected representatives of three different groups – Irish, African-American and Italian – to serve on the board. After the overwhelmingly favourable vote, the school sang a popular ballad in Italian.

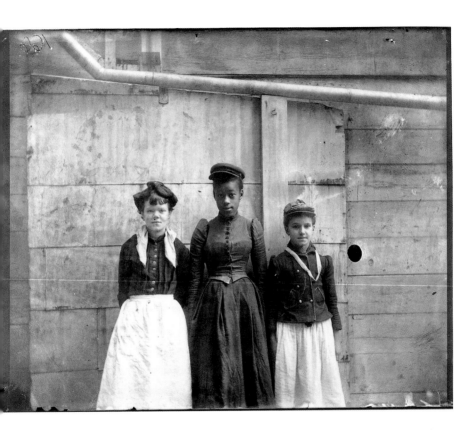

**Night School in the West Side Lodging-House, Edward the Little Pedlar Caught Napping, New York, 1892.** As Riis explained in *Children of the Poor*, nine-year-old Edward was an orphan who worked all day shouting for a pedlar. Edward refused to let Riis photograph him at work, so Riis took this picture as he slept during an evening spelling class at the Children's Aid Society lodging house where he lived.

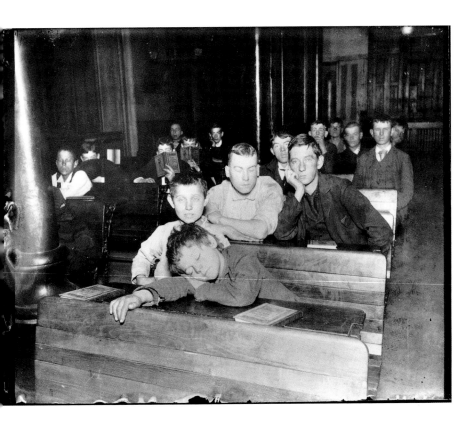

**A Synagogue School in a Hester Street Tenement, New York, 1892.** In *Childre of the Poor*, Riis described this school as 'a fair specimen of its kind – by n means one of the worst – and so is the back-yard behind it, that serves as th children's play-ground, with its dirty mud-puddles, its slop-barrels and broke flags, and its foul tenement house surroundings'. Riis believed synagogu schools, which emphasized study of the Talmud, should offer classes in English He praised the Hebrew Institute on East Broadway, where the Declaration o Independence was taught from Hebrew and Yiddish translations.

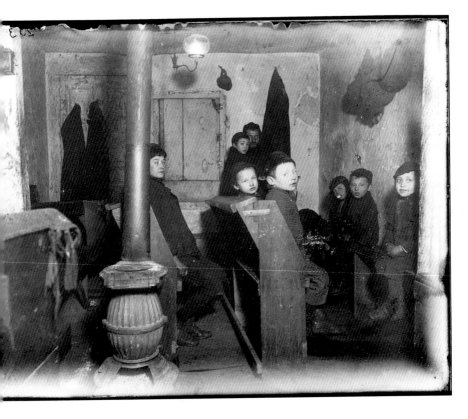

**A Truck for a Playground, New York, 1892.** Riis used this photograph of tw
boys playing in the back of a truck to illustrate 'Tony and His Tribe', a chapter i
*Children of the Poor* about a gang of toughs. He believed the overly restrictiv
rules, such as that forbidding playing ball in the streets and flying kites o
roofs, encouraged children to disregard the law. He lamented that the 'sma
parks that were ordered for [the children's] benefit five years ago exist yet onl
on paper.' It was the death of two boys playing under an old truck that finally le
to the construction of Mulberry Bend Park in 1897.

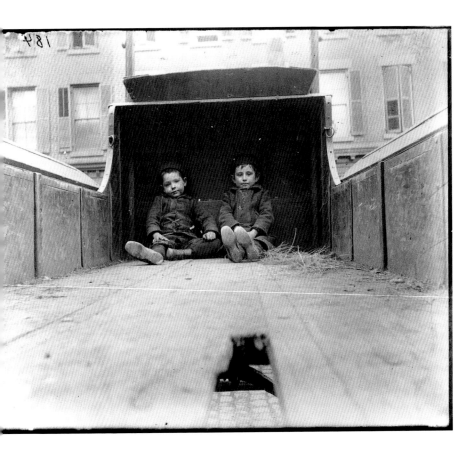

**Poverty Gappers Playing, Coney Island, New York, 1892.** In *Children of the Poor*, Riis reported enthusiastically about three privately funded sandlot play grounds, one of which was in 'Poverty Gap' on West 28th Street between 10th and 11th Avenues. Several vacant lots had been levelled, covered with sand and supplied with swings, seesaws, wheelbarrows and spades. Two teachers and a janitor were paid to keep order and to 'strike up "America" and the "Star Spangled Banner" when the [children] tired of "Sally in our Alley" and "Ta-ra-ra-boom-de-ay"'. The neighbourhood toughs called it 'Holy Terror Park', as a reminder of a gang killing that had occurred there before the site's transformation.

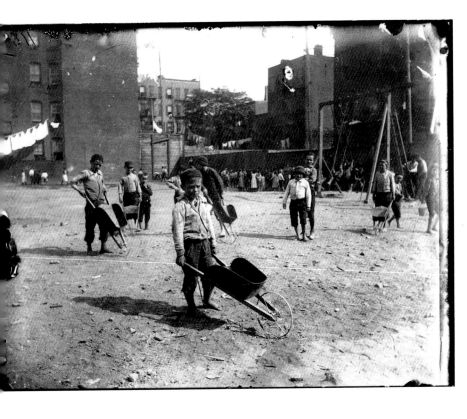

**'Slept in that Cellar Four Years', New York, 1892.** In *Children of the Poor* Riis described visiting a Ludlow Street tenement where three pedlars lived in a 'mouldy cellar [with] the water ... ankle deep on the mud floor'. 'It was an awful place, and by the light of my candle the three, with their unkempt beards and hair and sallow faces, looked more like hideous ghosts than living men. They had slept there among and upon decaying fruit and wreckage ... for over three years.'

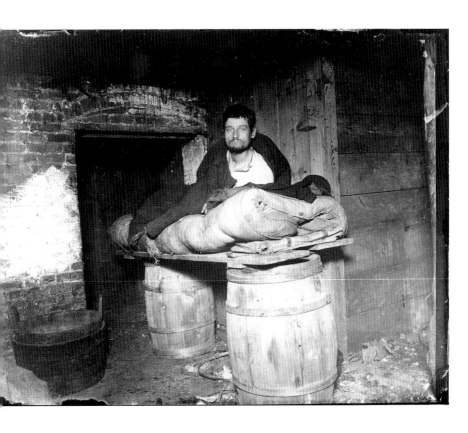

**An Italian Home Under a Dump, New York, 1892.** While investigating a murder at the Rutgers Street dump on the East River, Riis discovered a crew of Italian men and boys who lived under the dump, picking rags and bones from the city refuse. He decided to visit eleven of the city's sixteen dumps, where he found similar communities, despite a public-health law prohibiting them. In March 1892 Riis wrote, 'Real Wharf Rats, Human Rodents that Live on Garbage under the Wharves', for the *Evening Sun*. This Riis photograph, one of nine that appeared as line engravings for the article, shows a ragpicker's home at Rivington Street. The image was republished in *Children of the Poor*.

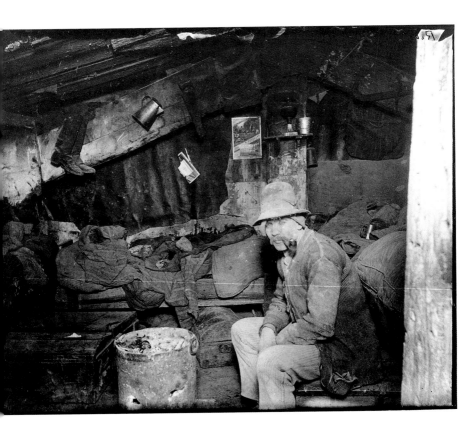

**Among the Offal at West 47th Street, New York, 1892.** This photograph, which appeared in 'Real Wharf Rats', shows the spaces under the piers where garbage scows dumped their cargo and ragpickers fashioned their makeshift shelters. Collecting bottles, cans, rags and bones during the day, the ragpickers slept in these cabins at night. Riis informed his readers that none of the materials was washed before resale.

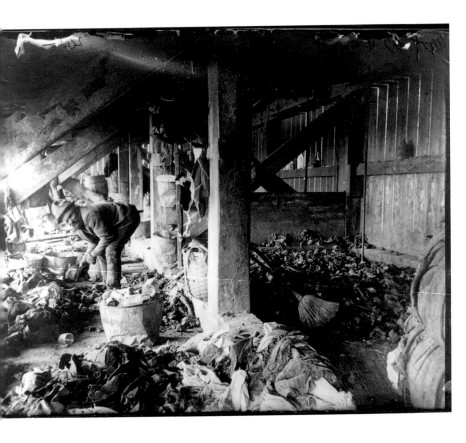

**Mulberry Street Police Station, Waiting for the Lodging to Open, New York**, **1892.** This photograph shows a crowd waiting on the cellar stairs of one of the city's twenty police stations that provided overnight lodging for the homeless. In *The Battle with the Slum*, Riis called these lodgings, which lacked water, light, ventilation, or beds, 'a parody of municipal charity'. In the winter of 1891 to 1892 Riis toured nine police stations, photographed their lodging rooms and wrote articles advocating their replacement with 'wayfarer's lodges' like those in Boston, which provided a bath, a clean bed and breakfast. The following winter a typhus outbreak in the houses led Riis to write more articles and give an illustrated lecture at the Academy of Medicine, but there was still no government action.

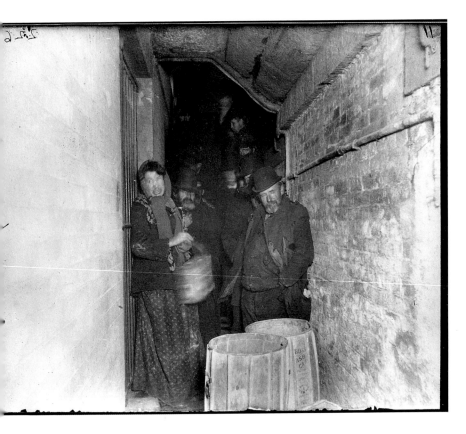

**Women's Lodging Room in Eldridge Street Police Station, New York, 1892.** the *Christian Union*, 14 January 1893, Riis wrote: 'Among forty-six women in th lodging-room of the Eldridge Street station ... there was not one who seeme less than fifty years old, and the great majority were apparently much olde That may have been the effect of the stale beer dive that makes its victim old early ... Drunken lodgers are not admitted under the official rule. Unde the sergeant's they are; their chances of freezing to death on a cold night ar better the drunker they are, as he well knows, and he does not want murder o his conscience.'

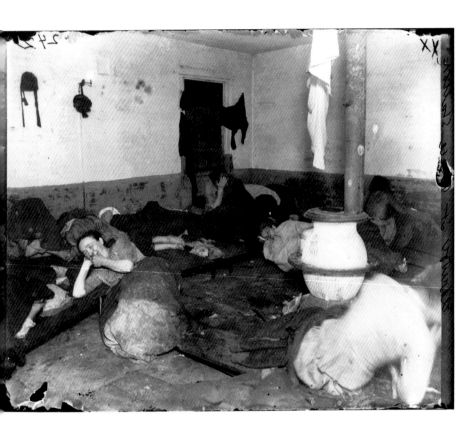

**A 'Scrub' and Her Bed — The Plank, New York, 1892.** In *How the Other Half Lives*, Riis explained that a 'scrub' was a beggar who worked for orthodox Jews on the Sabbath: 'The pittance she receives for this vicarious sacrifice of herself upon the altar of the ancient faith buys her rum for at least two days of the week at one of the neighborhood "Morgues".' This Eldridge Street lodger posed with the plank upon which she slept.

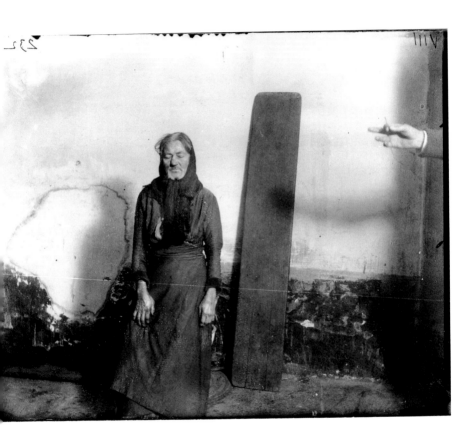

**Lodging Room in the Leonard Street Station, New York, 1892.** Riis foug[ht] against the widely held misconception that lodgers were primarily old tramp[s]. His report in the *New York Tribune*, 31 January 1892, described a visit to th[e] Leonard Street station, where he found twenty-eight lodgers, a third unde[r] twenty-five years old: 'There were two colored men ... down on the list a[s] natives; twelve of the rest were recorded as Irish, four as German and two a[s] English. There was one Scotchman [and] one Frenchman ... They were a[ll] stowed together in a room 12 x 20 feet ... A one-eyed English boy, nineteen years old, sat sadly by himself in a corner ... penniless after seeking vainly fo[r] work in New York for three weary days.'

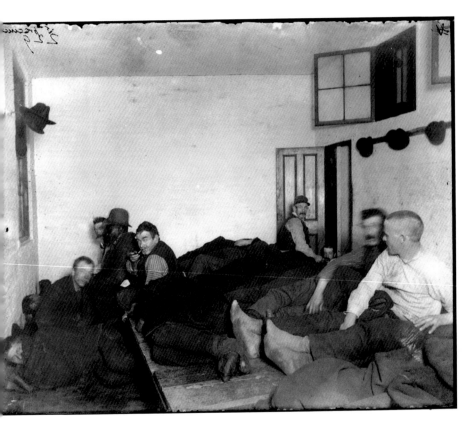

**The Church Street Station Lodging Room in Which I Was Robbed, New York, 1892.** Riis's campaign against the police lodging houses was animated by his own dreadful experience in the Church Street station the year he arrived from Denmark. Not only was he robbed of a gold locket, his only keepsake from home, but a policeman brutally killed his dog on the station steps. In *The Making of an American* Riis told how in 1896 he finally won the war against the police lodging houses: 'Standing there, I told [Police Commissioner] Roosevelt my own story ... "Did they do that to you?" he asked when I had ended ... He struck his clenched fists together. "I will smash them tomorrow." He was as good as his word.' This photograph accompanied the Roosevelt story in a chapter entitled 'My Dog Is Avenged'.

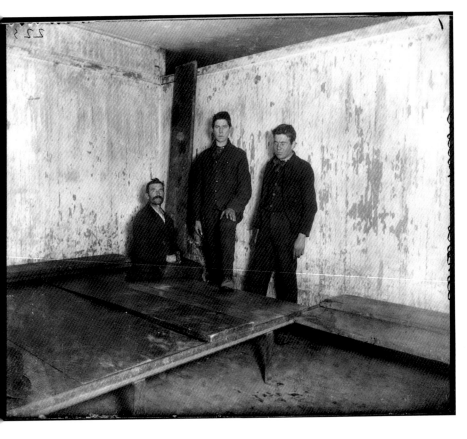

**Where They Burn Gas by Daylight – In the Essex Market School, New York 1894.** Riis published this photograph in 'Playgrounds for City Schools' in the September 1894 issue of *The Century*. He wrote: 'Already the teachers have to burn gas on the two lower floors on the brightest days, and in spite of the use of reflectors to catch what light struggles down between the tenements, the lower rooms resemble dungeons more than places for children to learn their lessons in.' In *The Battle with the Slum* Riis used this photograph to compare an old classroom with its spacious, well-lit counterpart in one of the city's new public schools.

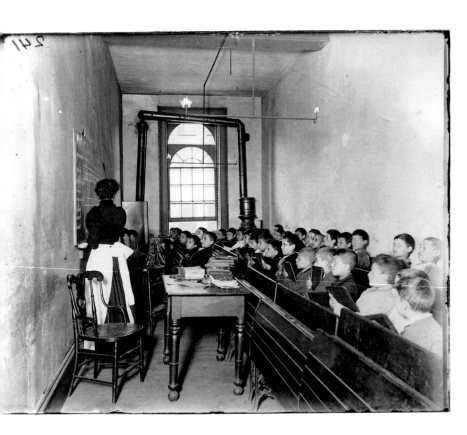

**The Hall Their Playground, Essex Market School, New York, 1894.** Because th[i]s
school was hemmed in by tenements, children spent play time packed into it[s]
dark hallways, which were lined with foul-smelling lavatories. By 1894, whe[n]
this photograph appeared in *The Century* article 'Playgrounds for City Schools[,]'
the school had been condemned. Riis criticized the city for not including outdoo[r]
playgrounds in the design for new schools. Reform was to come with new stat[e]
legislation for public schools at the turn of the century.

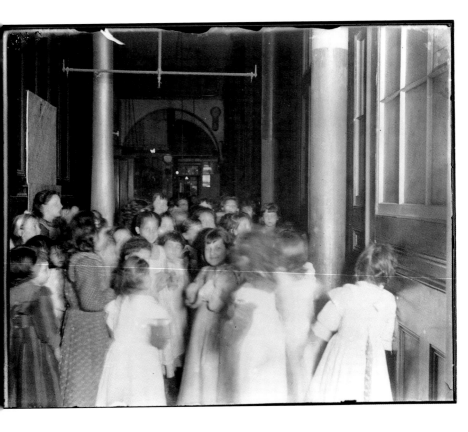

**The Street, Their Alternative, New York, 1894.** This view of Hester Street resembles the postcard views of the 'Jewish ghetto' that were common at the time. When he included it in 'Playgrounds for City Schools' in *The Century* (September 1894), Riis used the image to support his opinion that small neighbourhood parks and school playgrounds were essential to healthy child development. The street – the site of mischief, theft and gangs – presented an unsafe alternative.

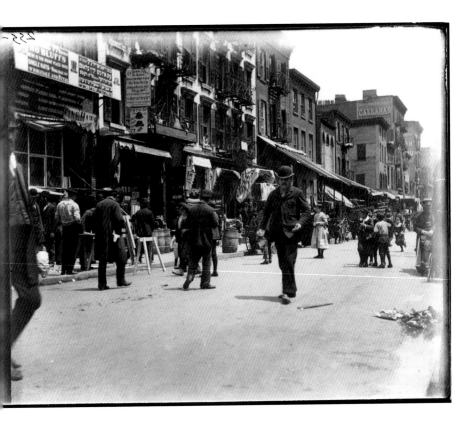

**The 'Slide' That Was the Children's Only Playground Once, New York, 1890s.** In *The Battle with the Slum*, Riis reminisced about having chastised a shopkeeper for hammering his cellar door full of nails to prevent children from using it as a slide. 'It was all the playground they had.' He illustrated the story with this photograph of a nail-covered cellar door on Hamilton Street in the Sixth Ward.

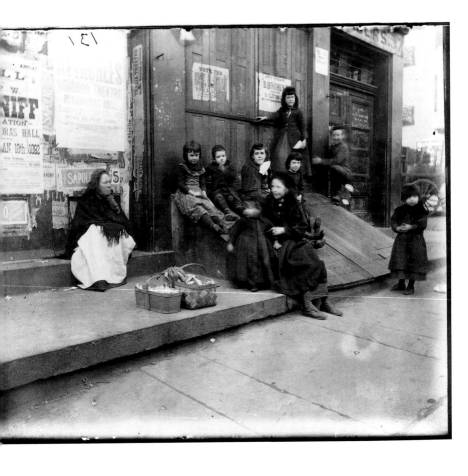

**The Baby's Playground, New York, 1895.** This haunting image of a small chi
wearing a dirty dress in a dark hallway conveys the gloom of tenement life. In
public lecture in 1903, Riis described taking the photograph: 'I went off and g
my camera and photographed that baby standing with its back against th
public sink in a pool of filth that overflowed on the floor.' To illustrate Riis's 189
article 'Christmas Among New York's Poor', a copy artist gave the child a fu
head of hair and placed household items as toys at his feet.

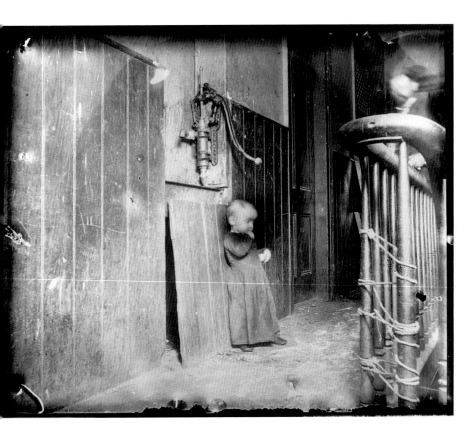

**Kindergarten Games, King's Daughters Tenement Chapter, New York, 1890s**
Riis advocated the kindergarten movement, which encouraged creative play for
small children. He took four photographs of the kindergarten run by the King's
Daughters Tenement Chapter, a settlement house at 50 Henry Street. Founded
in 1892, the settlement was renamed Jacob A. Riis House in 1901.

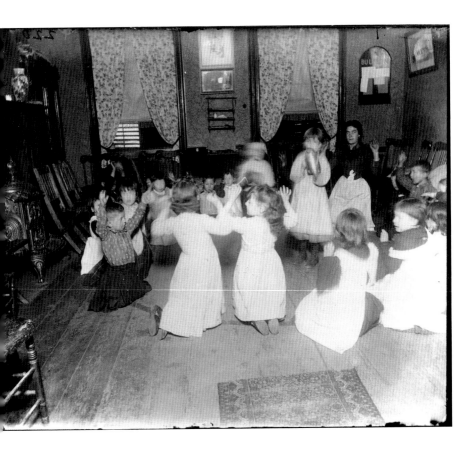

**Iroquois at 511 Broome Street, New York, 1890s.** Riis never published this photograph, but described a 'handful of Mohawks and Iroquois' in an article in the December 1897 issue of *The Century*. Living in the same neighbourhood as African-Americans, they supported themselves by 'weaving mats and baskets and threading glass pearls on slippers and pin cushions'.

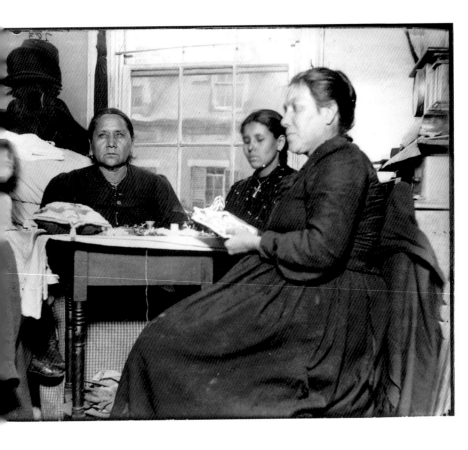

**Ludlow Street Cellar, New York, 1895.** In December 1895 Riis photographed three different cellars in Ludlow Street tenements, which were illegally used as residences. This image was never published.

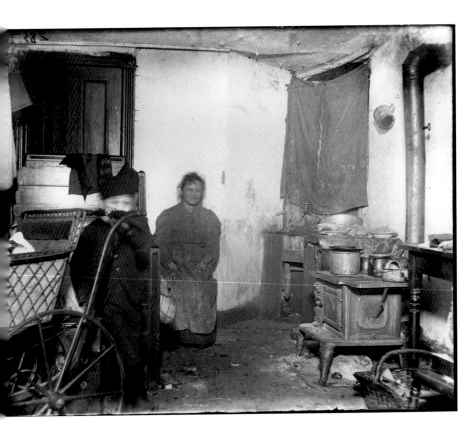

**Ludlow Street Hebrew Making Ready for Sabbath Eve in his Coal Cellar, New York, 1895.** In one of the three Ludlow Street photographs, Riis found a Jewish cobbler living in a coal cellar. In *The Journal*, 22 December 1895, he explained that, no matter how often the Board of Health cleared these residences, new families inevitably moved in.

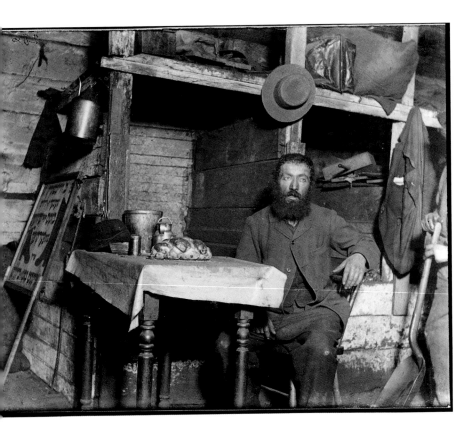

**The Wrecking of Cat Alley, New York, 1898.** Cat Alley, which opened on t[...]
Mulberry Street across the street from Riis's office, was no more than a yar[...]
with rear tenements. When it was torn down for the widening of Elm Street (now[...]
Lafayette Street), Riis photographed the demolition and wrote 'The Passing o[...]
Cat Alley' for *The Century*, December 1898. He later revised the article for *Th[...]
*Battle with the Slum*. Although Riis lauded the destruction of Mulberry Bend[...]
Gotham Court and the Mott Street Barracks, he regretted the end of what he[...]
called 'my alley'.

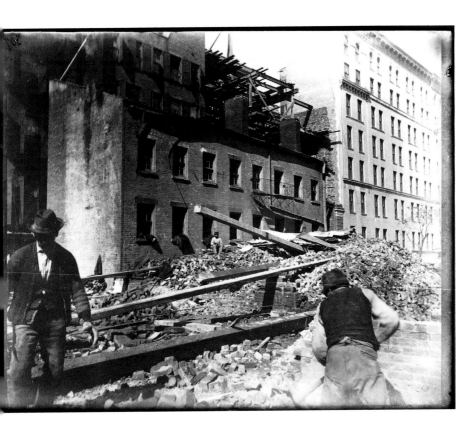

**Old Barney, New York, 1898.** When Cat Alley was torn down, Old Barney, a retired locksmith and Civil War veteran, refused to move. As debris rose to his third-floor attic room, he would leave only at night for provisions. When the room was ripped off the house, he finally moved out, dragging a trunk behind him. Riis saw him only once more, 'key-ring in hand ... looking fixedly at what had once been the passageway to the alley'.

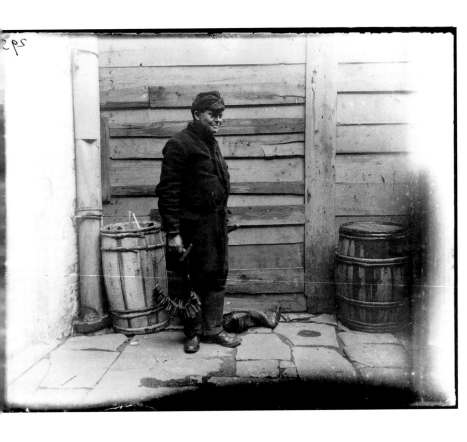

**Cat on a Tenement Steps, New York, 1890s.** Riis never found use for this charming study, taken at cat's-eye level, of one of the thousands of tenement cats that kept the rat population at bay.

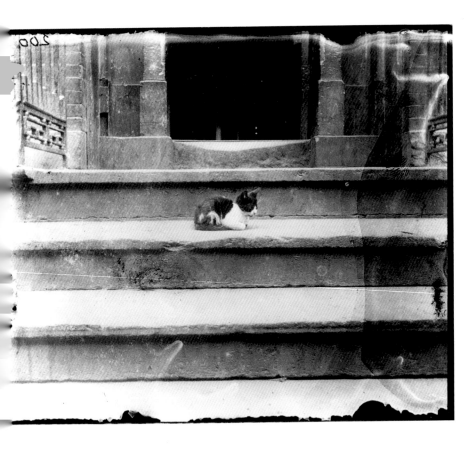

**1849** Born 3 May, the third of fourteen children of Niels Edward Riis and Caroline Lundholm of Ribe, Denmark.

**1858** Enters the Latin School where his father is schoolmaster.

**1864** Leaves school and volunteers for the Danish army in the war against Prussia and Austria.

**1865–1869** Becomes apprentice to a carpenter in Copenhagen.

**1870–1873** Leaves Denmark for America in search of employment and is rejected by his childhood sweetheart, Elisabeth Gjortz. Spends the next three years doing odd jobs, mostly as a carpenter and salesman, in New York, Pennsylvania and the Midwest.

**1873** Returns to New York City and secures a newspaper job with the New York News Association.

**1874–1875** Hired by the *South Brooklyn News*, which he later buys. Returns to Denmark, having sold the paper for enough money to allow him to marry Elisabeth Gjortz.

**1876** Returns to US and settles in Brooklyn with Elisabeth.

**1877** Hired by the *Tribune* and Associated Press as a reporter. Promoted to police reporter after six months. Does this job for the next twenty four years. The first of his six children is born.

**1884** Reports on the Tenement House Commission headed by Felix Adler.

**1887** First uses photography to illustrate slum conditions, with the assistance of Richard Hoe Lawrence and Henry Piffard.

**1888** First uses the camera himself and delivers his first slide lecture 'The Other Half, How It Lives and Dies in New York'.

**1890** *How the Other Half Lives* is published in book form and becomes a bestseller. Leaves the *Tribune* for the *Evening Sun*, where he remains on the staff for the next eleven years.

**1892** Publishes *Children of the Poor*, a sequel to *How the Other Half Lives*.

Concludes his most active period of taking photographs.

**1894** Begins publishing regularly in magazines, especially *The Century* and *The Outlook*.

**1895–1897** Becomes politically active during the reform mayoralty of William L. Strong. Adviser to Police Commissioner Theodore Roosevelt. Champions the clearing of Mulberry Bend slum and the razing of the Mott Street Barracks and Gotham Court.

**1898** Publishes *Out of Mulberry Street*, a collection of stories from *The Century*. Takes his last photographs.

**1900** His photographs are shown in the 'Tenement House Exhibition'. Publishes *A Ten Years' War*, summarizing the reform efforts of the 1890s. Suffers a heart attack. A heart condition plagues him for the rest of his life.

**1901** Publishes *The Making of an American*, which becomes a bestseller. Quits daily newspaper reporting to devote more time to lecturing. Becomes a national celebrity as adviser to Theodore Roosevelt, who is now President.

**1902** Publishes *The Battle with the Slum*, a revision of *A Ten Years' War*.

**1903** Publishes *Children of the Tenements*, a revision of *Out of Mulberry Street*.

**1904** Publishes campaign biography *Theodore Roosevelt, The Citizen*.

**1905** His wife Elisabeth dies of pneumonia. Joins Charities Publications Committee and begins writing for *Charities and the Commons*.

**1907** Marries his secretary, Mary Phillips.

**1909** Publishes *The Old Town*, stories about the Denmark of his childhood.

**1913** Moves to a 200-acre working farm in Barre, Massachusetts.

**1914** Dies at Barre, 25 May, and is buried there.

Photography is the visual medium of the modern world. As a means of recording, and as an art form in its own right, it pervades our lives and shapes our perceptions.

**55** is a new series of beautifully produced, pocket-sized books that acknowledge and celebrate all styles and all aspects of photography.

Just as Penguin books found a new market for fiction in the 1930s, so, at the start of a new century, Phaidon **55**s, accessible to everyone, will reach a new, visually aware contemporary audience. Each volume of 128 pages focuses on the life's work of an individual master and contains an informative introduction and 55 key works accompanied by extended captions.

As part of an ongoing program, each **55** offers a story of modern life.

**Jacob Riis (1849–1914)** is known first and foremost as a social reformer rather than a photographer. Riis was very aware of the new technology of photography and its ability to persuade and mobilize public opinion. He employed it, not for artistic ends, but as a powerful support for his campaign to alleviate poverty and clear New York of its slums. His book *How the Other Half Lives* (1890) is still in print today.

**Bonnie Yochelson** is a former curator of Prints and Photographs at the Museum of the City of New York, where she supervised the cataloguing and printing of the Riis collection. She is completing an interdisciplinary study of Riis with support from the National Endowment for the Humanities.

Phaidon Press Limited
Regent's Wharf
All Saints Street
London N1 9PA

Phaidon Press Inc.
180 Varick Street
New York NY 10014

www.phaidon.com

First published 2001
©2001 Phaidon Press Limited

ISBN 0 7148 4034 3

Designed by Julia Hasting
Printed in Hong Kong

A CIP record of this book is available from the British Library. All rights reserved. No part of this publication may be reproduced, stored in a retrieval system or transmitted in any form or by any means, electronic, mechanical, photocopying, recording or otherwise, without the prior permission of Phaidon Press Limited.

The Jacob A. Riis collection belongs to the Museum of the City of New York. The prints used in this book were made in 1994 from Riis' glass-plate negatives by Chicago Albumen Works.